poems
for
breakfast

**Poetry for kids and
adults who once were kids.**

First edition June 2021.

Book design and illustration by Jolyn Janis.

Library of Congress Control Number: 2019915627

Published by Migomax LLC
9901 Brodie Lane
Suite 160, #1018
Austin TX 78748

ISBN 978-1-7341144-0-9 (paperback)
ISBN 978-1-7341144-1-6 (ebook)

email: migomaxstudios@gmail.com
website: jolynjanis.com

TA-DA

I wrote a book of poems.
That's what I said I'd do.
I wrote a book of poems
So I can now show you
How awesome and amazing
We are at having fun.
I wrote a book of poems,
~~And now that book is done.~~
A NEW JOURNEY HAS BEGUN.

POEMS FOR BREAKFAST

"You can't eat a poem!"
My mother cried out.
She told me to stop with
What that's all about.

I told her you can,
And I'll prove it, too.
I'll eat a few poems,
Then rhyme 'til I'm blue.

I ate one or seven
To get a good taste.
I'm careful to sip them—
No words go to waste.

My face starts to tingle.
I start to feel funny.
The ones I just ate
Feel strange in my tummy.

They gurgle inside me
And sit like a rock.
That's when it happened—
They released with a POP!

Dime-climb-time-mime,
Chimichanga and lime.
Soup with some thyme,
And that's all of my rhyme.

I thought that was it,
That rhyming was over,
Then up came the sip
That tasted like clover.

Fat-cat-splat-bath-mat
Dat-rat-sat on flat hat,
Gnat-pat and wombat,
Chit-chat with that bat.

After that second
Burst of rhyming was through,
I felt so much better,
But my face was bright blue!

ANT FARM

They were all here the other day,
Eleven ants that work, not play.
I thought they liked it in their farm.
We'll get them back, don't be alarmed.

Can you please help me find them here?
They must be close, they should be near.
Let's count them as we find them all.
Look closely, as they're very small.

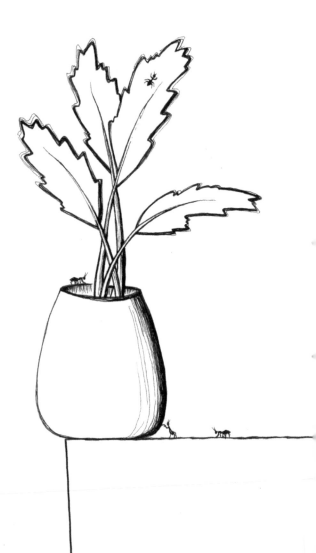

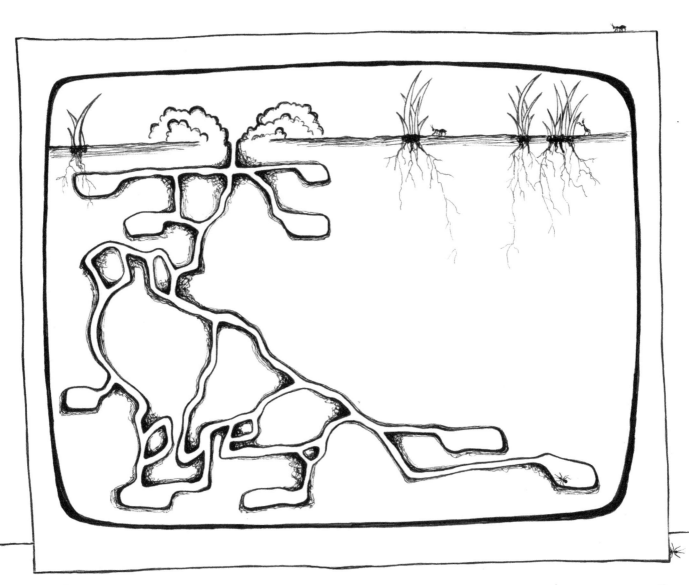

ABOUT YOUR SHOE

I ate your shoe.
Yeah, I ate your shoe.

I just ate your shoe
'Cuz I love you.

I can't call you on the telly,
So I ate your shoe.

I can't scratch my own belly,
So I ate your shoe.

There's nothing more smelly,
So I ate your shoe.

'Cuz I love you,
I ate your shoe.

I don't know what else to do.
I just love you,

So I ate your shoe.
'Cuz I love you.

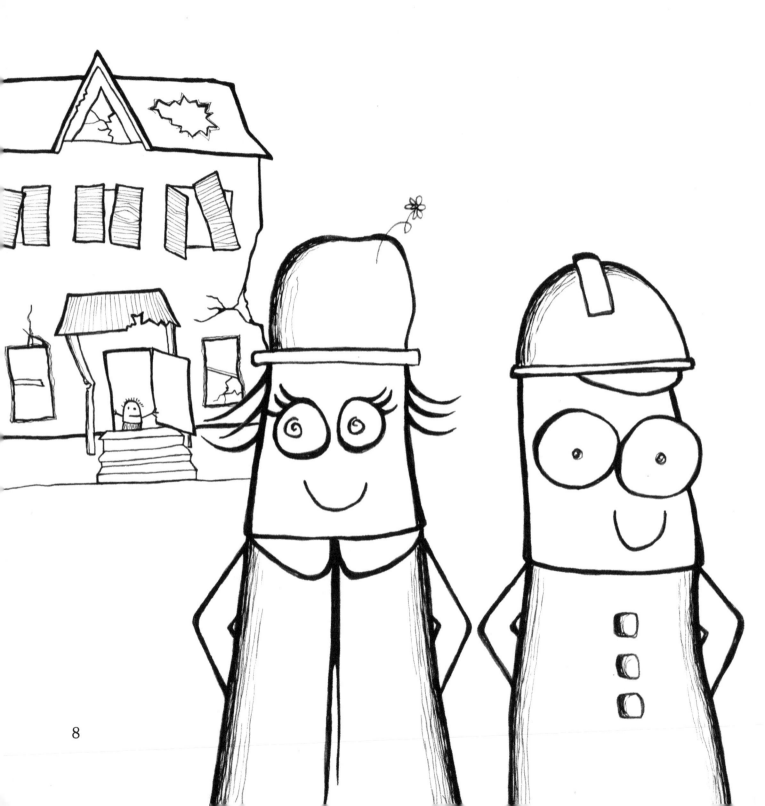

BARTZ AND BARBS

Bartz the builder made a house,
He made it super sturdy.
He double-checked all the beams
And called it live-in worthy.

One day Barbs the breaker said,
"Let's share your sturdy house."
Bartz the builder said to her,
"Sure thing! Come be my spouse."

Bartz the builder loved his Barbs—
He thought the deal quite fair.
Barbs would break and Bartz would build.
They made a perfect pair.

WHURRY

I think I've lost my Whurry.
Oh no, he may be lost!
All my busy made me hurry,
And I didn't see the cost.

There is a sense of nothing
When Whurry goes astray.
It's sort of like a something
That up and runs away.

I track him for a while,
Until he hides again.
Then Whurry pokes his head out
And tries to play pretend.

Soon, he sneaks back over
And snuggles in his place.
And in the night I sense him
Filling in the empty space.

Now I tell my Whurry,
I won't worry very long.
We have a new agreement
To stay calm and carry on.

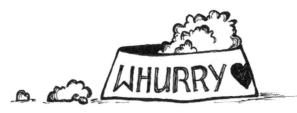

EDDY

Get ready in the eddy,
Get ready to swim out.
Get ready for the current,
Get ready to find out.

What's ready past the eddy
Has been ready for so long.
It's ready for your heart to sing,
A glorious new song.

MAYBE

It's dangerous,
I've tried it.
Well, not really . . .
I know someone who did.
Well, not really . . .
I heard about someone who did.
Well, not really . . .
I thought about someone who did.
Who may have . . .
Who could have . . .
Listen.
All I'm saying is that
Something that happened
In my head
May happen to you.
So whatever may become,
Is maybe coming for you, too.

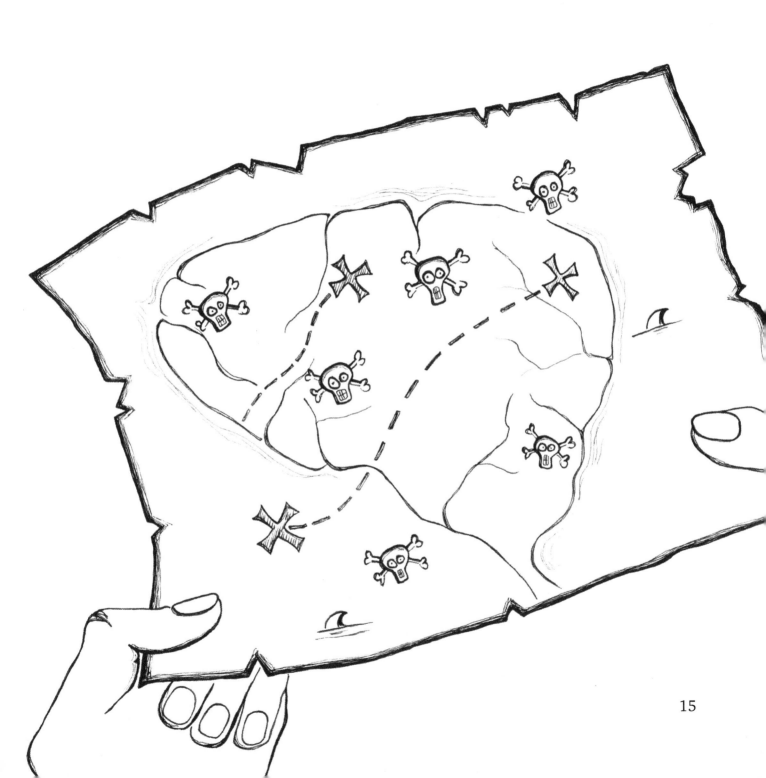

DIVIDE

In a town called Divide,
Right through the center,
Is a great big long line . . .
Choose your side when you enter.

When you pick your side,
You can't cross back over,
Or awful things happen,
And then it's all over.

They thought nothing of it,
And stayed on their sides.
That's just how it goes—
It's the fate of the tides.

Until this one day,
A new girl rode by
And asked the big question:
"Why lines, and why sides?"

They looked at each other,
They'd mumble and chat,
They asked all the elders
And consulted the cat.

No one could give her
A solid reply,
So she danced on both sides,
And she didn't die.

Nor did she vanish
Or shoot to the moon
For crossing the line
Or stepping too soon.

So then they gained courage
To crisscross that line
And change their town name
To the town of Combine.

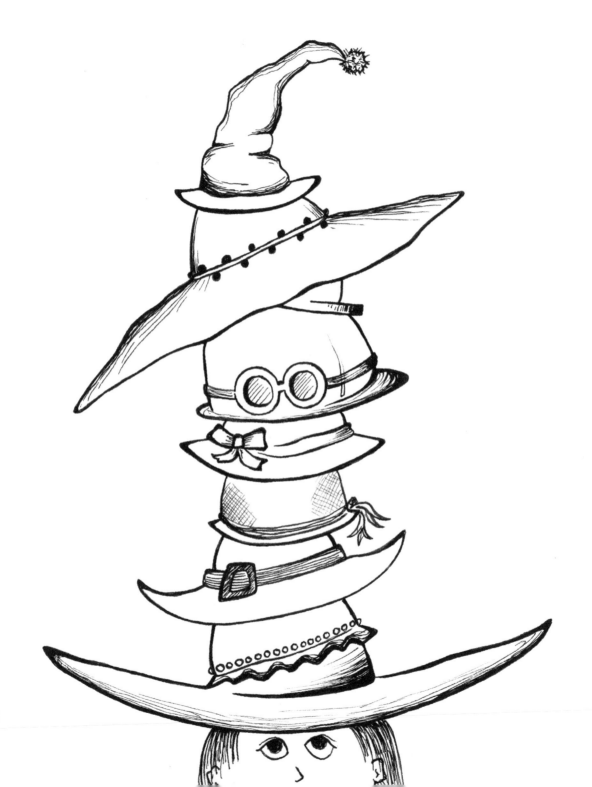

MORE HATS

Sir, where's your hat?
Your hat for your hat.
One is not enough—
You certainly know that.

You need more.
You need four.
Here's one that
No one wore.

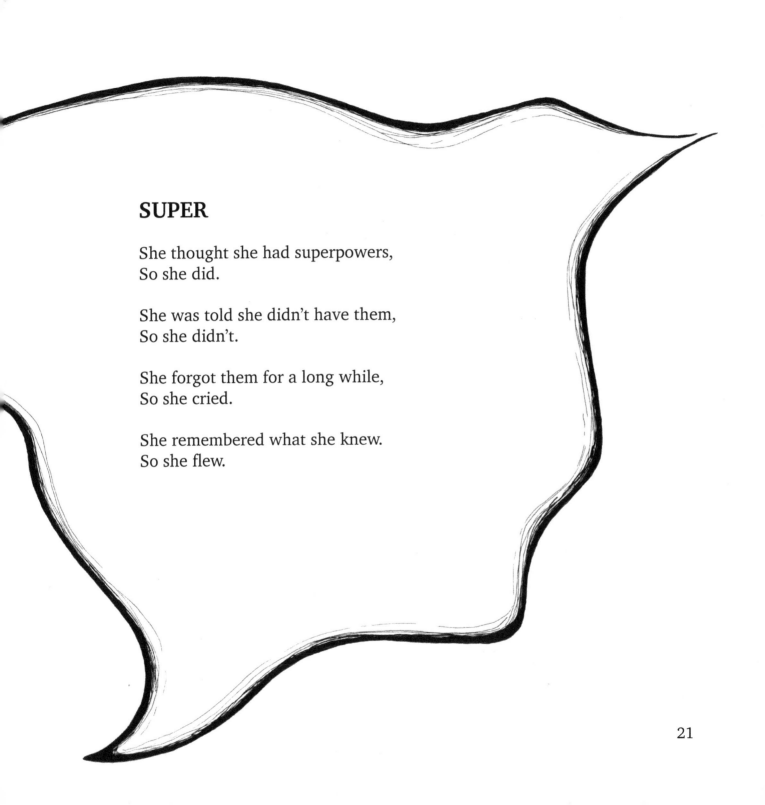

SUPER

She thought she had superpowers,
So she did.

She was told she didn't have them,
So she didn't.

She forgot them for a long while,
So she cried.

She remembered what she knew.
So she flew.

21

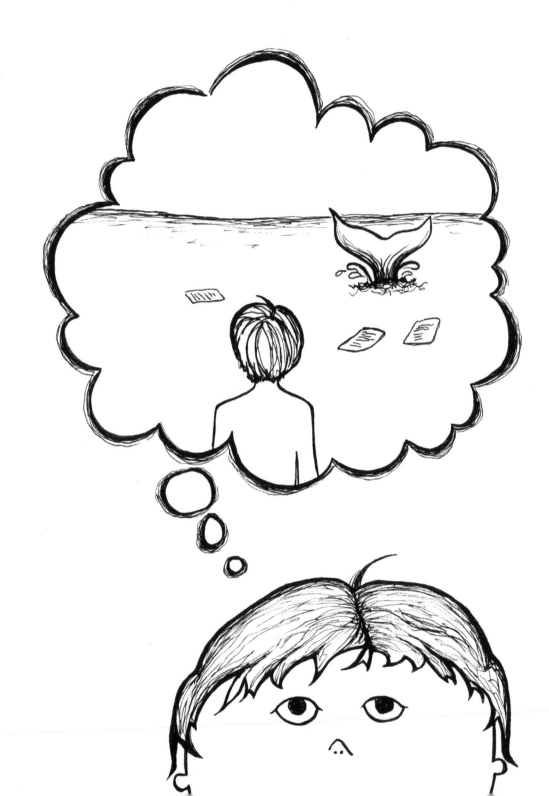

MERMAID

A mermaid ate my homework,
And then swam out to sea.
I found three pages in the waves.
The words no longer read.

I'm sorry not to have it here—
Can't stop a mermaid's feast.
Instead, I'll write her story.
It'll be my masterpiece!

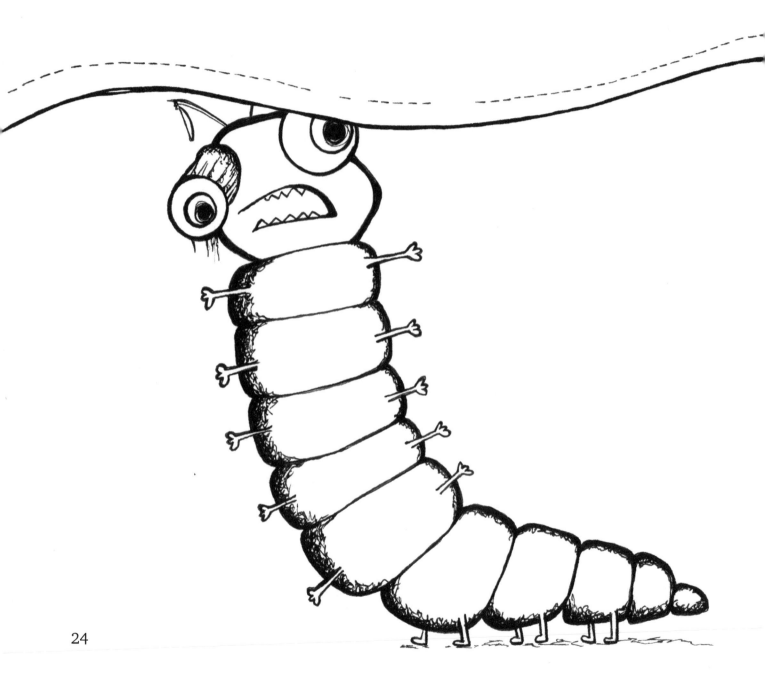

ZOMBIE CATERPILLAR

Zombie caterpillar,
Underneath your bed!

Zombie caterpillar,
Coming for your head!

Zombie caterpillar,
Looks alive but dead!

Zombie caterpillar,
Watch out where you tread!

THE MOON

When the moon shines red, it's time for bed.
When the moon shines hazy, it's time to be lazy.
When the moon shines bright, the cats will fight.
When the moon shines dark, the dogs will bark.
When the moon shines yellow, it's gonna be mellow.
When the moon shines green, you're due to spring-clean.
When the moon shines blue, put a coin in your shoe.
When the moon shines orange, it's . . .
What's that? Nothing rhymes with orange?
That's just crazy.
What about garnge and flarnge and starnge?

26

DEAR POPSICLE,

I'm so excited about you.
Oh, the many flavors you are,
And the glorious taste of pink,
And the mysteries that may be.
Maybe you have a magical center,
So I dive in with delight,
Open your wrapper just right,
And eat you up just as you start to melt.
Then . . .
BRAIN FREEZE!
Why, Popsicle, why?
It feels like the pain will never
Ever ever ever be over
As long as I live.
I may die this way.
"Goodbye, world. Farewell, Popsicle,"
I whisper with blue-stained lips.
Oh, all the things I never did,
And the places I never traveled.
Then, just as fast as it came,
The pain rushes out,
And normal rushes in,
And normal now feels . . .
Well,
Normal feels amaaazing now.

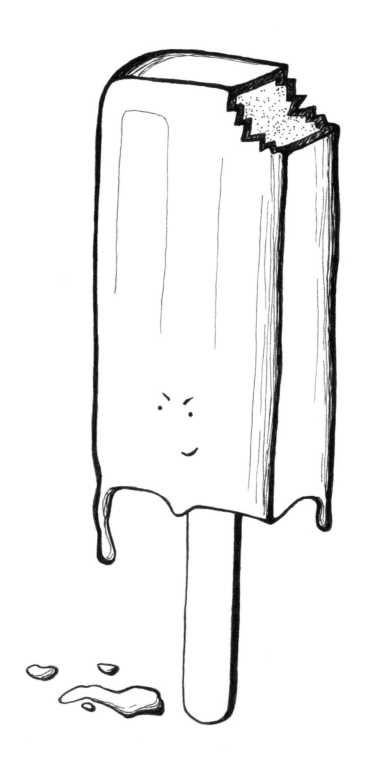

TIME

Time is magic,
Don't you know?
It's quite the thing.
It's quite the show.

POOF!

You see now?
There it goes.
Where did it go?
Well, no one knows.

THAT JIM

'Member that time
We really wanted cake,
So we learned how to bake,
And Jim dropped it in the lake?

'Member that day
We really wanted to swim,
So we packed our stuff with Jim,
Then it rained just over him?

'Member that week
We really wanted to dance,
So we frolicked and pranced,
'Til Jim tore his pants?

'Member that morning
We wanted sweet buns,
We told Jim we had none,
So he brought thirteen tons?

NEW PET

What pet should we get?
This one who's soaking wet?
Or the spotted one named Bret?
Or the last one that we met?
There's that shaggy one—don't forget—
That looks like our last pet.
Maybe let's get a set—
Two pets we won't regret!
Let's make a pet octet.
We can sing and call it Colette
And drive a '61 Corvette
Riding off into the sunset.
Now we have to get a Corvette
To drive around our new pet.
Maybe we shouldn't be so set
On what new pet we get.

STUPID PANTS

I tore my pants off today.
It's okay.
I didn't like them,
And they didn't fit,
And they reminded me
Of the me who is sad
And mad
At my ugly pants,
Which don't fit
The new me that I see.

I've promoted the sad, mad me,
And put him to work in a job
Where he feels free.
He's now in charge,
Of Happiness Hospitality,
And he loves it,
Because he can now see
That there always was
Another way to be
Than the sad, mad me.

MOST-BEST

Do the most with your best.
That's all you can do.
It's your own most-best.
The most-best part of you.

MIRROR

The person in my mirror,
She smiled at me one day.
I don't know why I did it,
But I pushed her far away.

In time I got to notice
How much pushing felt alone,
So then I started smiling
And savor the unknown.

I know now what they noticed,
That I did not yet glean.
The person in my mirror,
Is the me I had not seen.

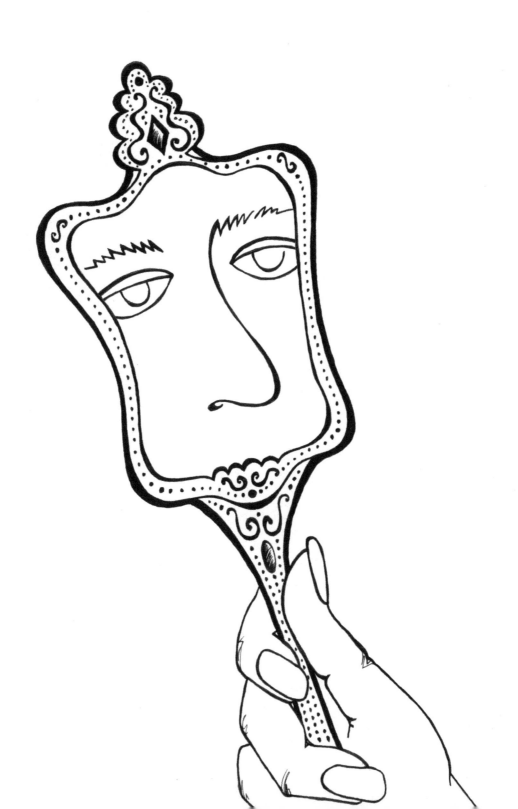

SUSIE SNOO

Susie Snoo in a polka-dot muumuu
Strolled throughout the small town.
She had the longest arms of all
And never was seen with a frown.

Every day she had her big jar,
Collecting jokes and good tries.
She mushed and mixed them in a bowl,
Then made them into pies.

THE ELEPHANT

What do you do
When you can't squeeze past
The elephant in the room?

You try to be nice
And talk real concise,
With an elephant in the room.

He sits and he stares,
And he plays with your hair.
He's the elephant in the room.

But we all play along
And sing the same song:
"There's no elephant in the room."

SING
THIS
PART

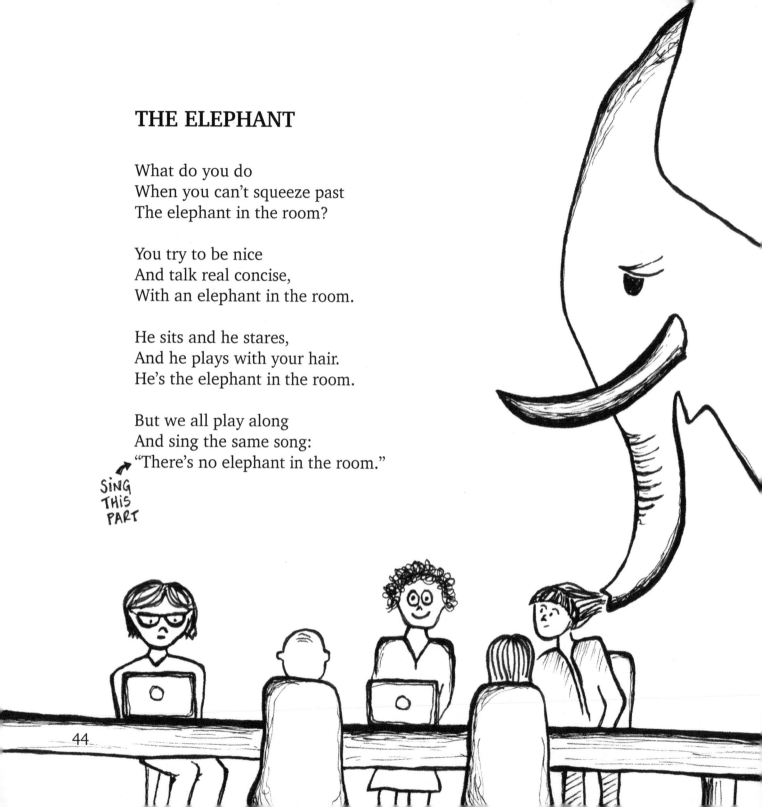

44

IF

If a tree falls in the forest
And no one is around . . .
Did it make a sound?

If a bug falls in some honey
And no one saw it die . . .
Did it say goodbye?

If a dish falls in the kitchen
And it was a mistake . . .
Did it even break?

MASTER MIND

Who is the master
Of your own mind?
You are the master.
Hope you don't mind.

Who is the leader—
The hero, the one—
That you have been waiting for
Second to none?

I SAY

There's an interesting way
That most people say
They don't have a way
To say what they may.

I say . . .
There's a way to say
What you say you can't say:
Just say another way.

49

BALL AND BOY

Once in a village not too far from here,
There lived a strange creature shaped like a sphere.
He rolled out of bed more smoothly than most,
And traveled so quietly, some thought him a ghost.

He tried not to bother the people in town,
Some tried to say hi, but always he'd frown.
This creature was taller than their tallest wall.
No one bothered to name him, so they called him "Ball."

One boy came upon him and stared right back
At the ginormous Ball that was painted all black.
"Blah" said Ball to the boy who still saw.
The boy blinked his eyes and said nothing at all.

"Blah" said Ball again to the boy,
To which the boy replied, "Ah, you need a toy."
The boy told Ball to follow him to the store.
Ball followed along, for staying was a bore.

The boy went inside and came out with a thing
That was shaped like a sphere, and when shaken, it rang.
Ball got excited and jumped up with joy.
"Blah, blah, blah!" said Ball to his brand-new toy.

The boy watched Ball play ball with his ball,
And bounce on the wall, and in joy, watch it fall.
The boy started home just in time for his dinner.
"Blah blah!" yelled Ball, cuz he felt like a winner.

51

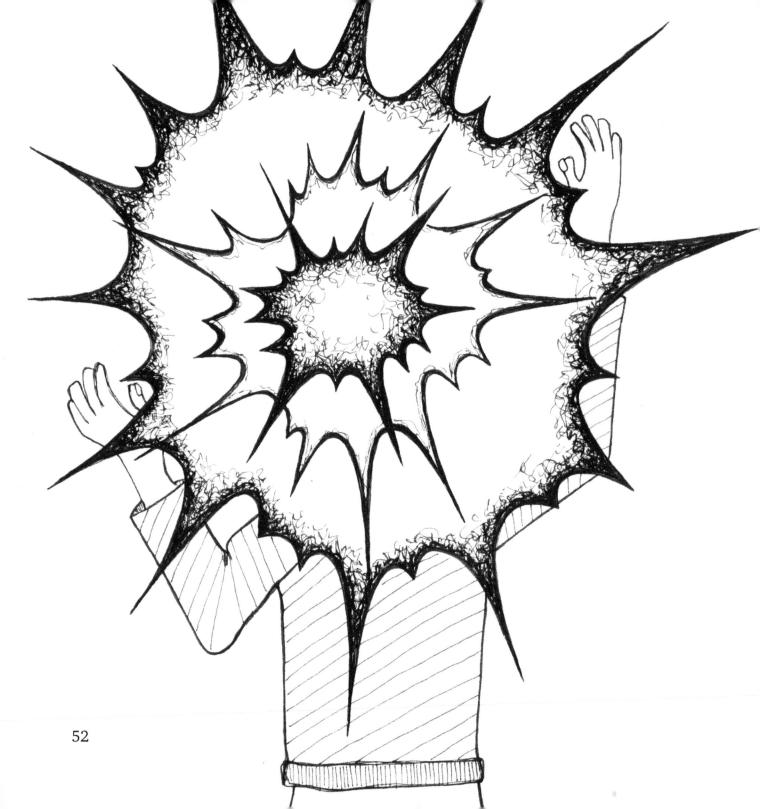

EXPLODE

I think my head just might explode!
I used to think that's true.
That all it takes is one small thing,
And off the head just blew!

Now I know it's only
Something Mommy jokes to Dad.
That doesn't really happen
Unless she's really, really mad.

SPACEBOY AND EARTHGIRL

He lives inside his spaceship
With pictures on the wall.
Spaceboy lived a lonely life—
At least he's safe from all.

Earthgirl lives amongst the trees
And dances under stars.
She loves to chase the butterflies
And imagine life on Mars.

She came upon him one fine day
Stuffed in his small spacesuit.
She watched him for a while,
She found it quite the hoot.

"Remove your silly helmet,
And let yourself just be!"
She yelled it from the hilltop
Where he could barely see.

He pushed a little button
That opened his front mask.
And in rushed all the freedom
For which he'd always asked.

PET MY BELLY

What do I do? I can't find my shoe.
"You can always just pet my belly."

What do I do? I am feeling so blue.
"You can always just pet my belly."

What do I do? I haven't a clue.
"You can always just pet my belly."

What do I do when I can't resist you?
I guess I'll just pet your belly.

57

LIGHT BULB

There's a light bulb up above me,
It's just too far to reach.
Once I can get up there,
I'll have something to teach.

We all know that a light bulb
Brings ideas that make you smart.
And once I can get up to it,
My smart life will then start.

FUSS

When lots and lots of people
Try talking all at once,
They stumble on each other,
And make a big ol' fuss.
Their talking looks a lot
Like messy, jumbled words,
That no one can make sense of,
Like

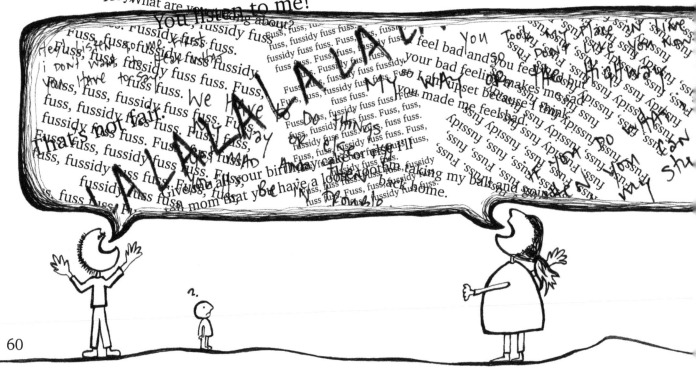

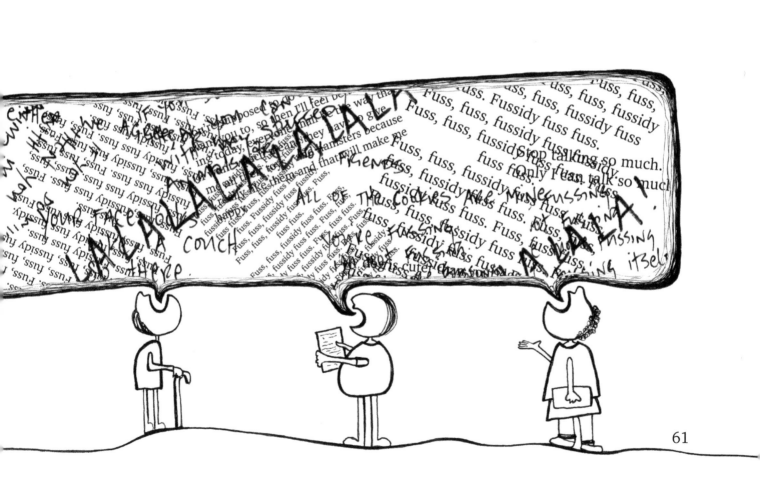

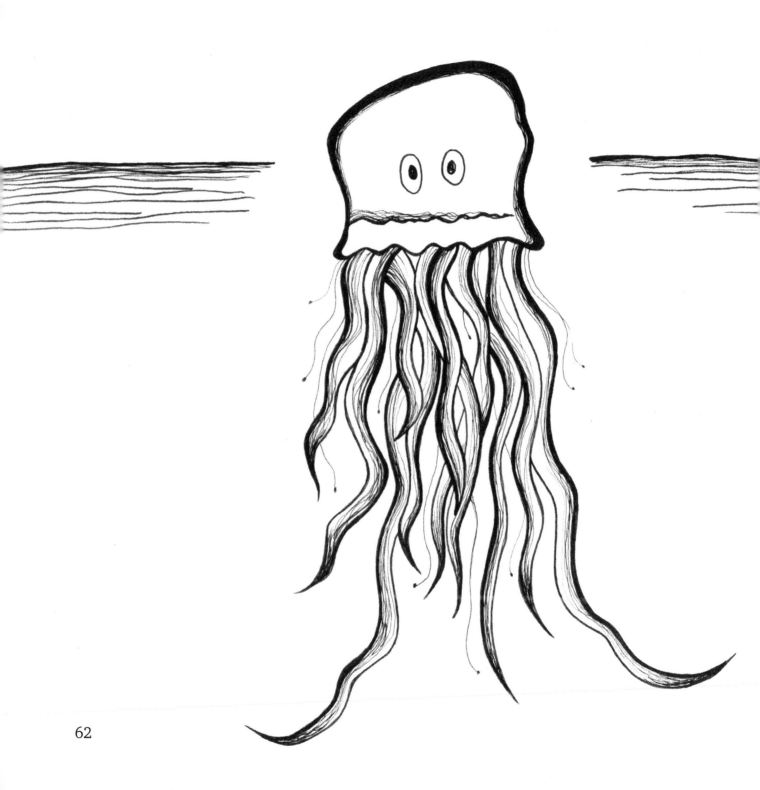

JELLYFISH

A jellyfish stung my bottom.
It's turning red and blue!

A jellyfish stung my bottom.
Or maybe it was two!

A jellyfish stung my bottom.
I think I'm going to die!

A jellyfish stung my bottom.
It's coming for my eye!

TV HEAD

Some say I'm a TV head,
But I don't think that's true.
I'm simply not that well-read.
Big difference 'tween the two.

A TV head is someone
Who always watches shows.
Like *Zombies Come at Twilight*
And *Extraordinary Toes*.

Or *Desperado Rabbit*
Finds Another Tail,
And *Bam the Armadillo*
Runs Smack into a Pail.

I'm not like those people
Who always talk about TV,
And doesn't read any books,
But can you name a book for me?

65

TEACHER'S PET STEW

You told me not to write about
The green goblin in my closet.
Or fairy friends that brush my teeth
And skeletons who vomit.
So I'll just tell you something else
That I don't think you knew.
I'll tell you of the day I made
A Teacher Pet Stew. Ew!
I started with a sprinkle
Of Margie's brand-new shoe,
And added her school notebook,
And crayons and blue glue.
Then a block of butter,
So when she tries to talk,
Her words go slipping from her mouth,
And it's hard for her to walk.
Margie may be great at staying neat
with the craft glue,
But I like her much, much better,
In my Teacher's Pet Stew brew.

Come see me

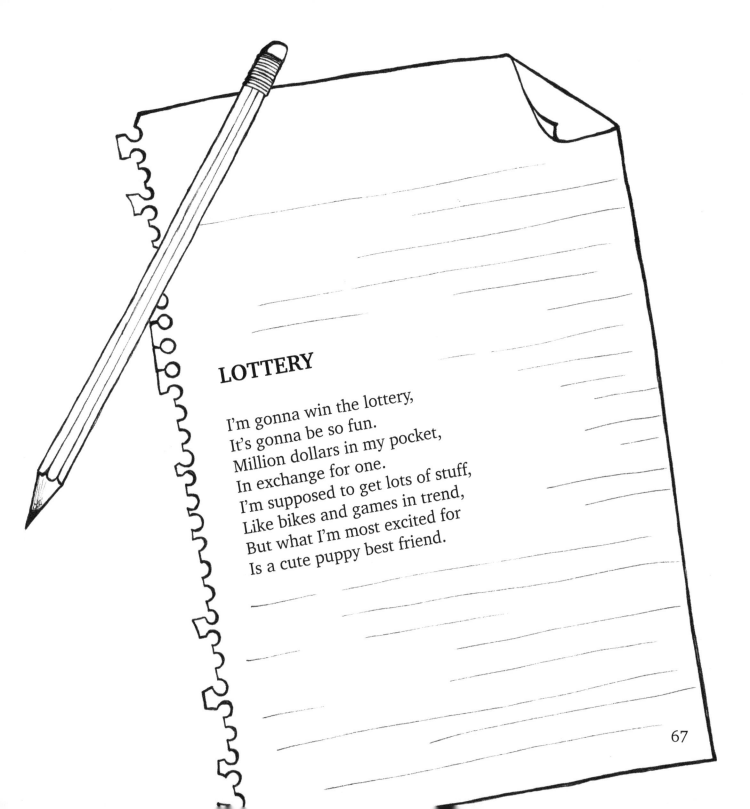

LOTTERY

I'm gonna win the lottery,
It's gonna be so fun.
Million dollars in my pocket,
In exchange for one.
I'm supposed to get lots of stuff,
Like bikes and games in trend,
But what I'm most excited for
Is a cute puppy best friend.

HELLO, SPIDER

Great work, there.
Tell me . . .

How do you bear
All that you weave,
Working so much
To try to catch dreams?

If no fly is caught,
You've weaved it for nothing,
And on the next day,
You don't have a something.

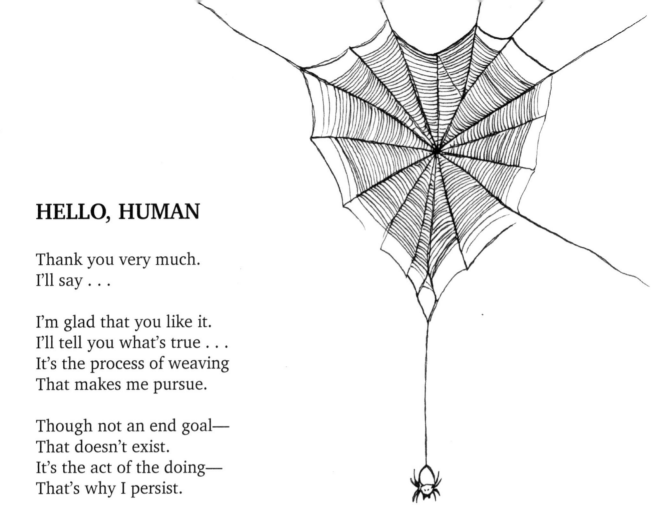

HELLO, HUMAN

Thank you very much.
I'll say . . .

I'm glad that you like it.
I'll tell you what's true . . .
It's the process of weaving
That makes me pursue.

Though not an end goal—
That doesn't exist.
It's the act of the doing—
That's why I persist.

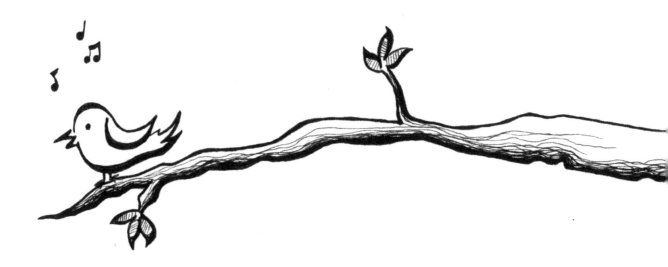

HUG

I just want a hug.
One hug ain't so bad.
But most run away
And then I get sad.

One day a nice bird
Did not fly or flee.
It whistled a tune,
And I said with glee…

"I'll be right over!
It may take a week.
I just need to grow
Another few feet."

MUNCHY NOMSTER

What do Munchy Nomsters eat
When they need a snack?
They have crunchy letter treats,
Feasting in a pack.

Munchy Nomsters eat a lot,
They chew and gnaw and smack.
Swimming in from page to page,
So fast I can't keep track.

There's one way to stop them flat,
Before they all attack.
First, you have to

old poem
on ground

and then

and at the perfect

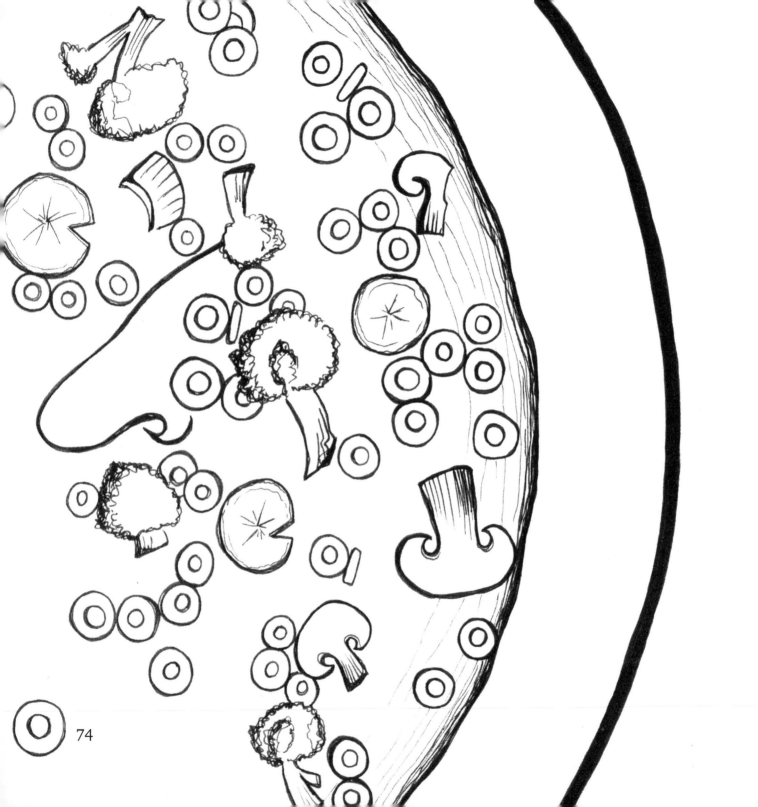

MY FACE

My face fell off this morning.
Have you seen my left eyeball?
It rolled under the sofa,
Or out into the hall.

My nose got really dirty—
It fell into my soup.
I lost it in the veggies
And pasta shaped like hoops.

My lips, I found them first—
They held on to my collar.
I put them back on tightly,
Then I shouted and I hollered.

FIVE BILLYS

I remember one day,
Dad did something silly.
He came home with hay
And five goats named Billy.

We looked at the goats,
And they looked at us.
We had no clue yet,
How much they would fuss.

Billy One ate a piece,
Of Mom's brand new fleece.

Billy Two loved to chew,
On bottles of glue.

Billy Three always peed
On whatever he pleased.

Billy Four broke the door,
And danced on the floor.

Billy Five stood upon,
The car that's now gone.

None of them ate
The hay that we got.
They ate all the grass
And the plants in the pot.

Mom said to Dad,
Like I thought she would,
"No more goats named Billy."
And we all understood.

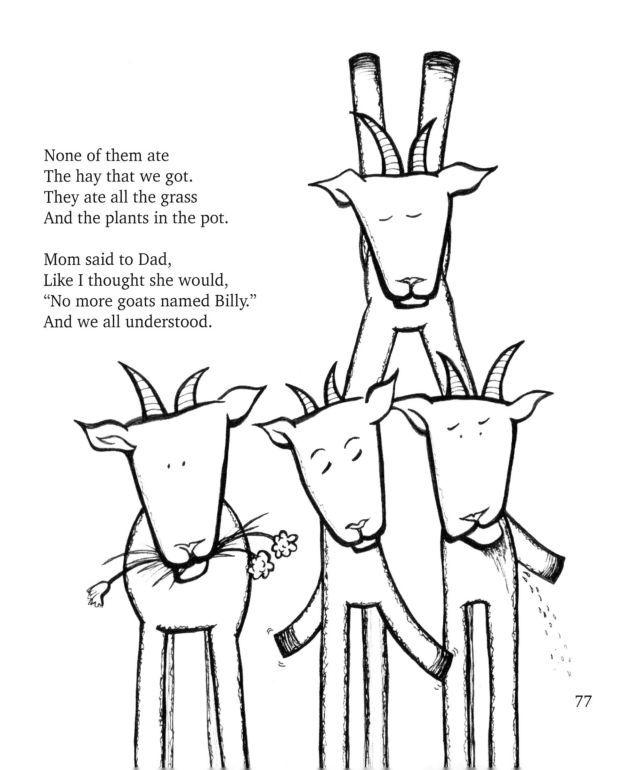

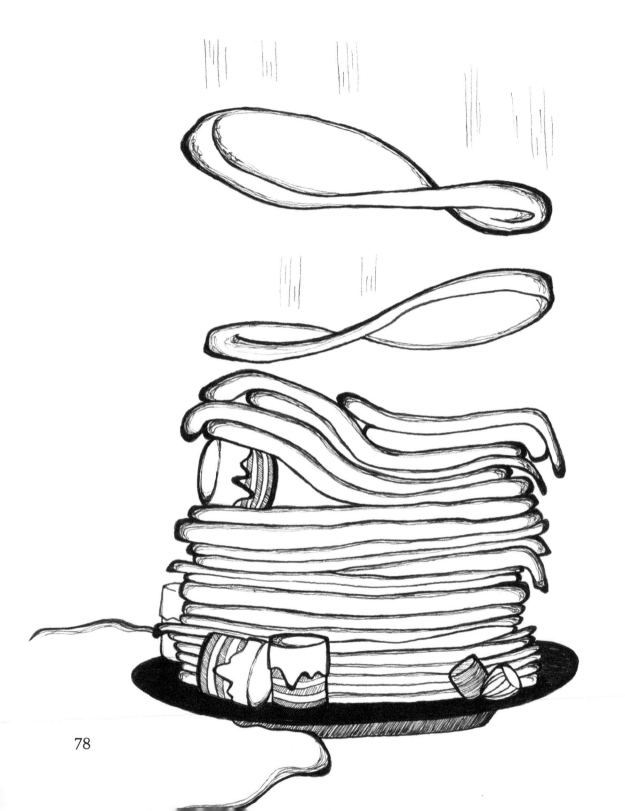

PANCAKES

Dad made pancakes today.
We all had such a blast.
He poured in too much flour,
And made a mess real fast.

He asked us what we wanted
To put into the batter.
We said to add some cookies
That Mom left on the platter.

We said Mom adds some other
Yummy sweet things in as well—
Like lots of giant marshmallows
With chocolate-covered shells.

Dad mushed it all together
And cooked them up with glee.
But Mom came home too early,
And we ran to watch TV.

A GOOD NIGHT

I thought I was afraid,
Of monsters in the dark,
But then I got real brave,
And I set them all apart.

I named each one I knew,
The first was Silly Saul.
Then Kooky Kam and Snockers,
Who both wish they were tall.

Allie Rex was next in line,
I thought of Goober Dee.
She said she likes her name just fine,
And she's sorry she scared me.

When all of them got names
And we settled in to sleep,
They all wished me good night
And no one made a peep.

TALL MAN

Hey there, really tall man.
I hope you're well today.
Wow, you are much taller
Than you look from far away.

Just have a few questions,
I hope that is okay.
Things I've often wondered,
I'll just ask without delay.

Do you see the sunrise
Before it's really day?
Does sound take a long time
'Till you hear what people say?

Do you snack on cloud puffs?
Oh! Yes, and by the way...
Can you lift me over
The new superhighway?

83

MEETINGS

A meeting for a meeting,
Is just how it is done.
We need to have too many,
Instead of only one.

One meeting is at seven,
And five just after lunch.
Two more are wedged between
Another while we munch.

Some meetings are quite useful,
Important things get done.
But most of them are extra.
We can make good use of one.

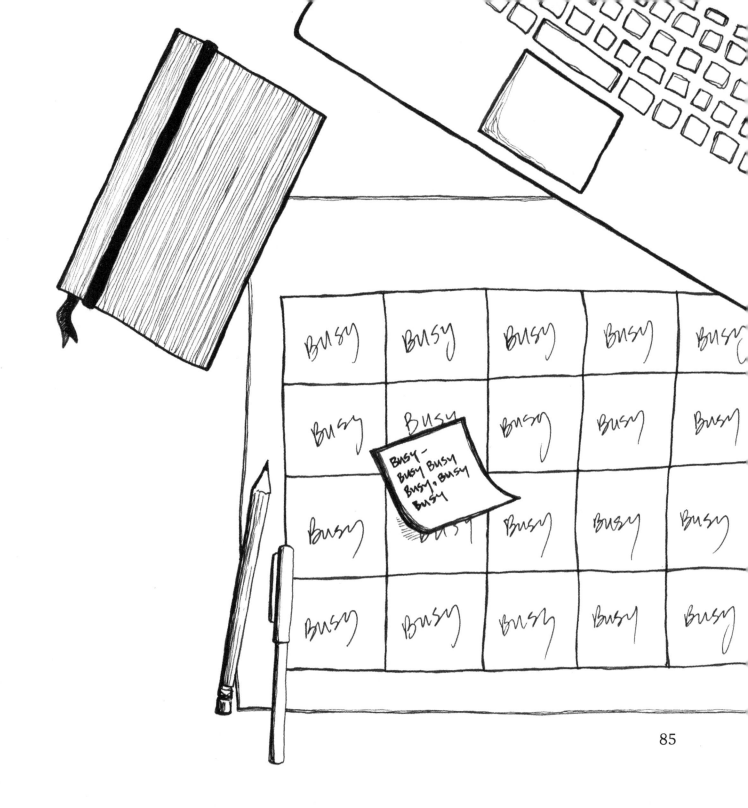

BITTERSWEET

Life is like a bunch
Of stupid chocolates no one wants.
The yucky ones with cream,
Or the coconut with nuts.

Or the pink ones with white lines.
Why ever pink with lines?
How strange we eat such things
As pink squares with thin white strings.

Or the round and flat squished cracker
With dark chocolate as a backer
That usually gets left awhile,
All stale and broken in a pile.

Or the ones rolled in a round,
With all those shavings sticking out.
Strange candies, oh so sticky,
And they look so super icky.

I won't like it, but I'll try,
And I'll taste it with a sigh.
Biting one, I know I'll hate.
You know, I could just suffocate.

Like I thought . . . it's just okay,
But there's flavor, I must say.
It's not as bad as I thought up—
Tastes like candied buttercup.

Can I try just one more, please?
I only want it just to see.
Thank you. Yes, it's not as bad
As some other ones I have had.

Just one more, and then I'll stop.
I'll take a bagful to my pops.
He sure does like your sweets a lot.
These are Pop's. Don't bust my chops.

DINNER

Paw Paw the cat made us dinner today.
Yeah, it was good, I really must say.
He said it was fresh tuna casserole.
Where's all the food that I put in his bowl?

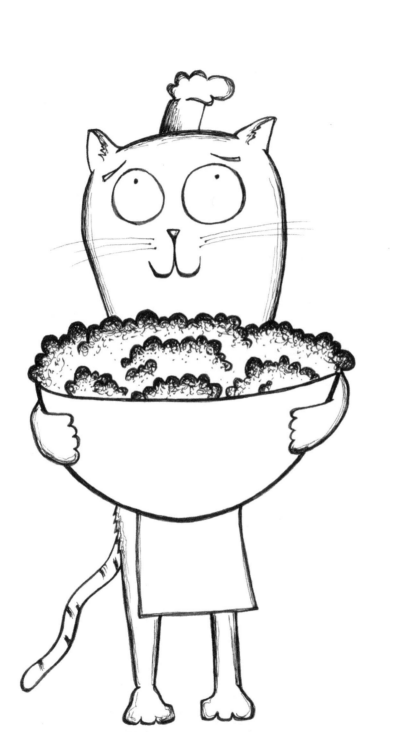
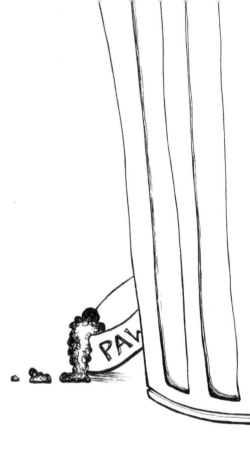

HAND PUPPET

My hands look like puppets.
Just add two eyes.
No fancy costumes.
TA-DA! Disguise!

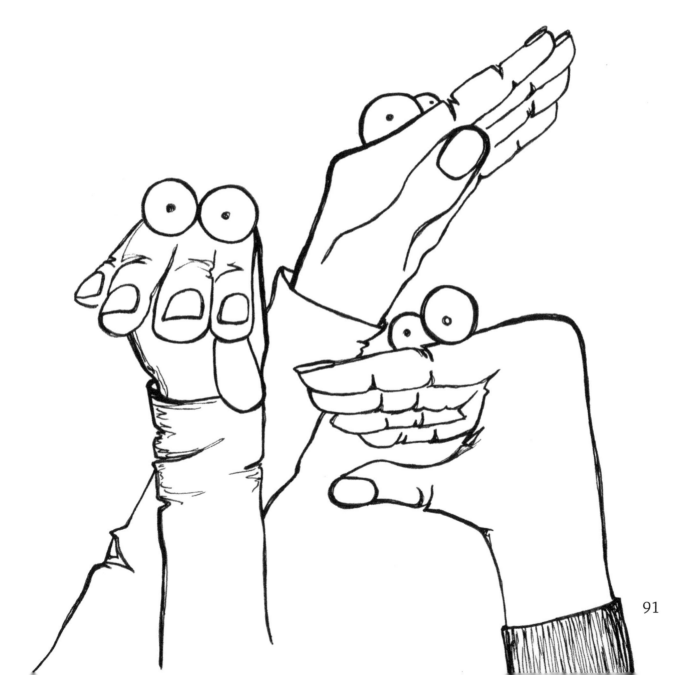

SMILE

I have this fun saying,
And here's how it goes:
Smile at all strangers,
Don't look at your toes. (OR PHONES)

What they feel inside,
You might never know.
There likely is something
That they haven't shown,

And just your one smile
Can make their heart glow.
So smile at strangers.
You just never know.

HEART

I looked across the country,
I looked out to the sea,
I even checked the mountain view,
To see where you could be.

I looked up on the moon,
And in everyone I met,
I thought I'd find you somewhere,
Yet nowhere I would get.

It felt like you were far away,
And finally I stopped,
To sit and think of where and when
You could have taken off.

Then I felt you in my arms,
Said you were never gone.
I promise to remember that,
Inside, my heart shines on.

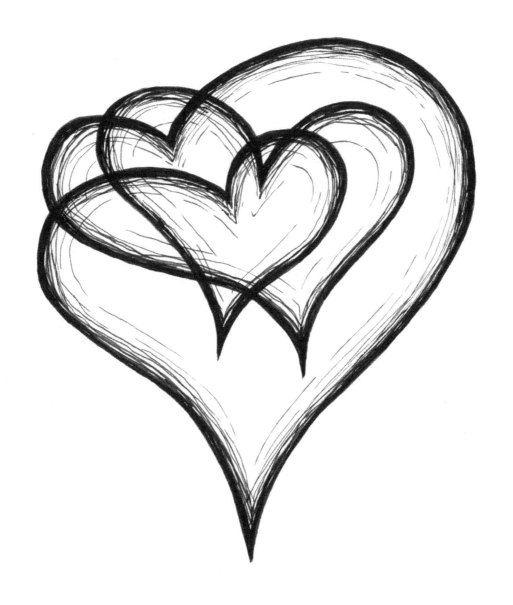

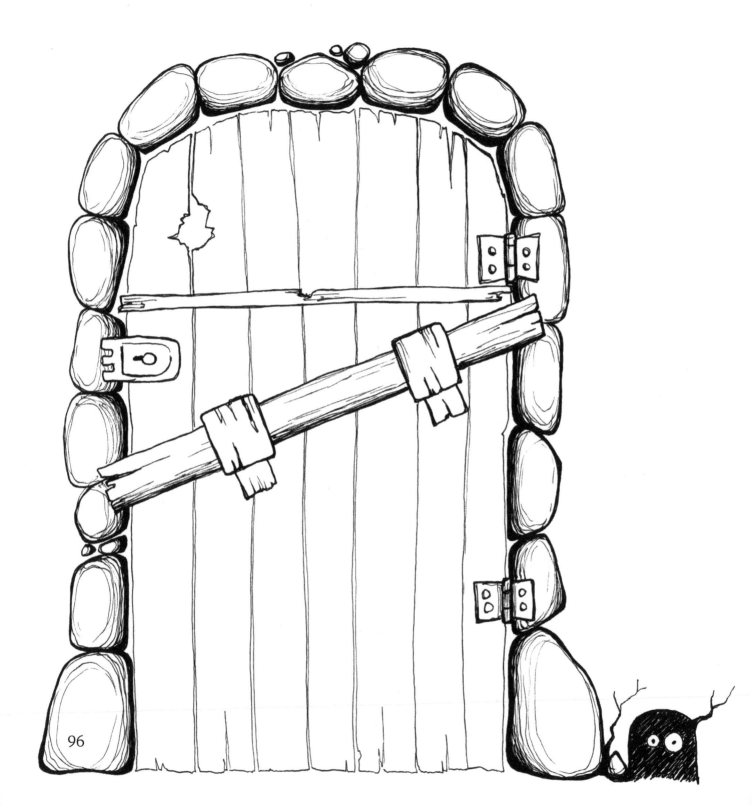

TRY

Try the door.
Try it some more.
It may now be open,
You should know for sure.

Try it today.
What did you say?
Someone is pushing
From the other way?

I'll go and see
Who this person might be.
Oh! It's old you who's stopping
The you who could be.

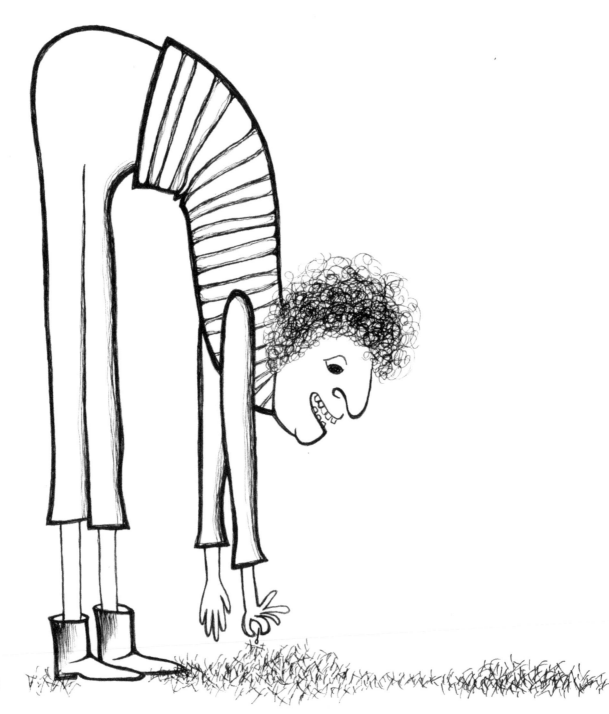

ELDA PONTOVER

Ms. Elda Pontover,
She tried to bend over,
And got pretty stuck that way.

She dangled both hands
And made hunched-over plans,
Like finding the needles in hay.

CRICKET

There's a cricket in the wall.
Or maybe down the hall.
Either way, I hear it all.
I can't wait until late fall.

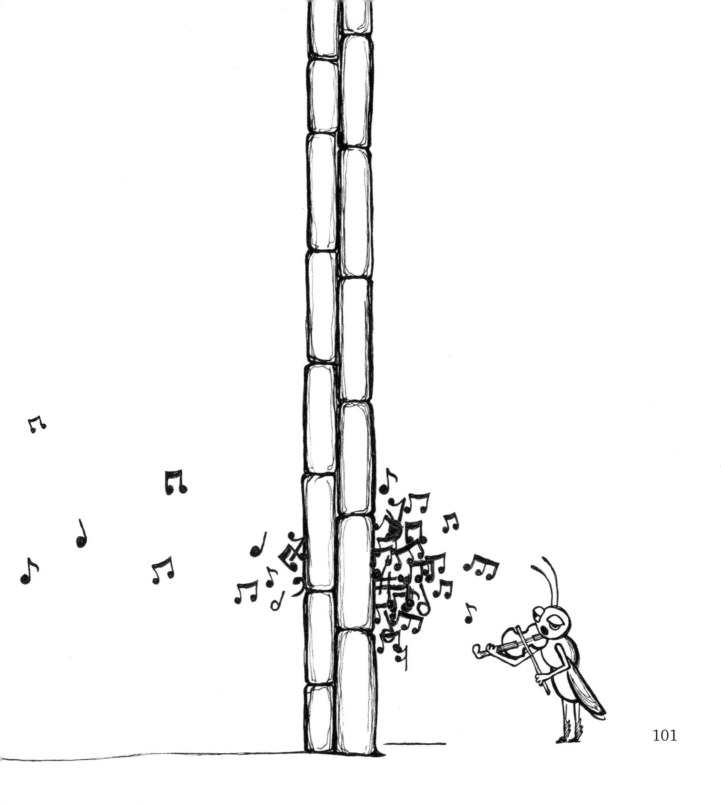

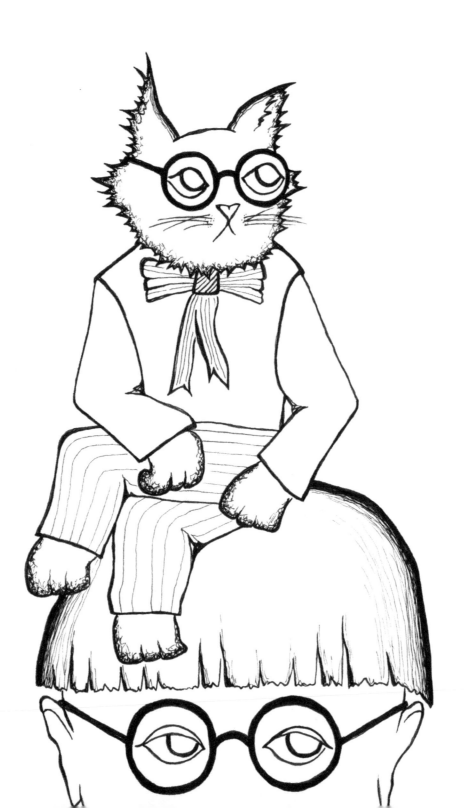

CAT SAT

Cat sat on my pillow,
Cat sat on my bed.
Cat sat on the table,
Then sat on the bread.

Cat sat on the dresser,
See the hair he shed?
All that, I could handle,
'Til cat sat on my head.

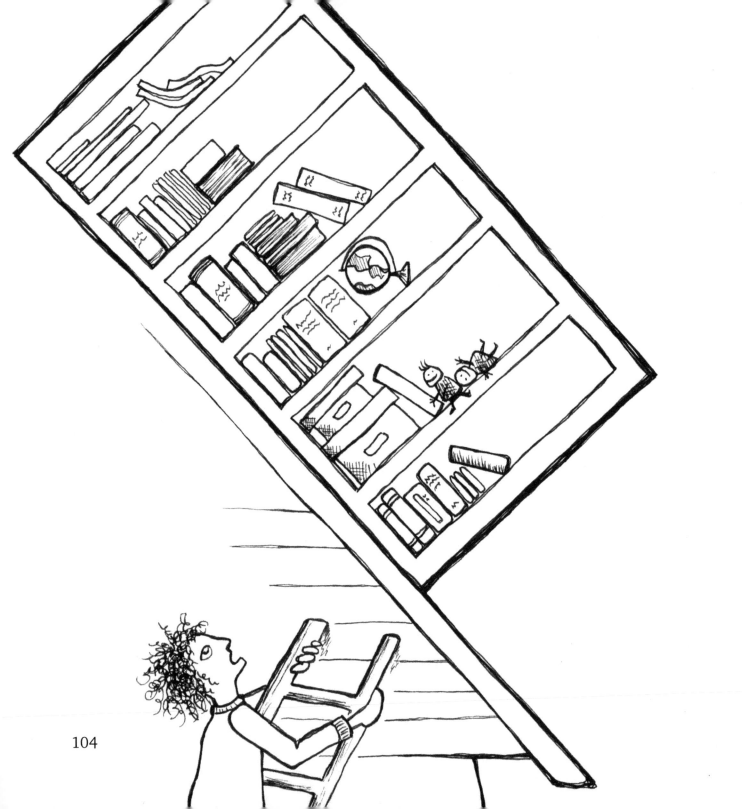

MAGIC ROOM

My room has magic powers.
It moves all on its own.
Like when I'm in the shower,
Or when I'm not even at home.

One day at home I found
My bed was in the hall,
And also my big fish tank
Had been moved with fish and all.

My aunt doesn't believe me,
Says I did it all myself.
But how do you explain that
On the roof is my bookshelf?

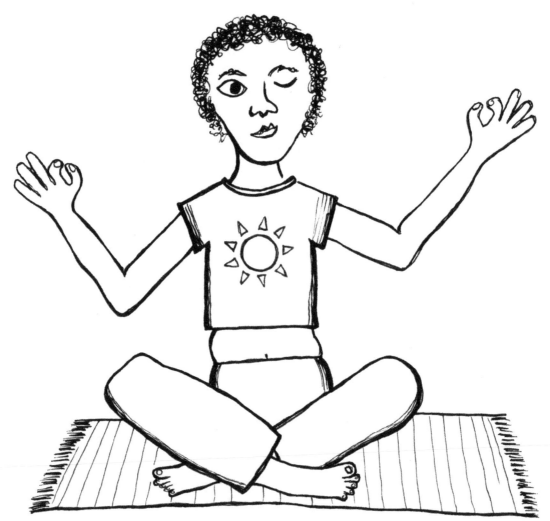

MEDITATE

I'm gonna meditate today.
I'm so excited!
But first,
I have to check the stove . . .
Okay, it's off.
And then,
I need to get a snack . . .
Ready now.
Wait,
I forgot to shut the door . . .
Okay, done.
This chair is kinda lumpy,
And it makes me sit all slumpy.
Okay, much better.
Ahh.
Wait!
What's that sound?
Oh, man . . .
The dog is snoring now.

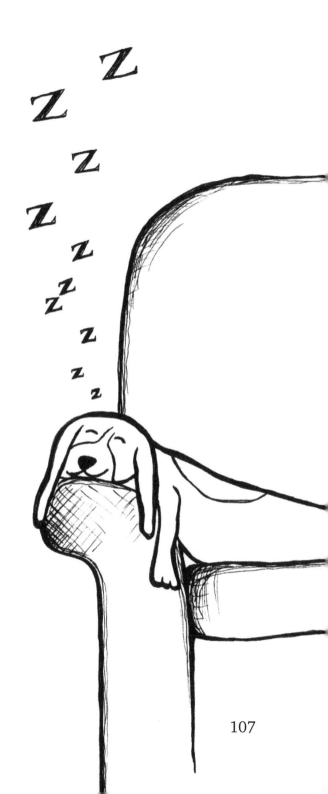

107

UNICORNS

Unicorns are cool and all,
Their magic will leave you in awe.
But what do you do with uni-poo in your shoe?
Do you tell anybody at all?

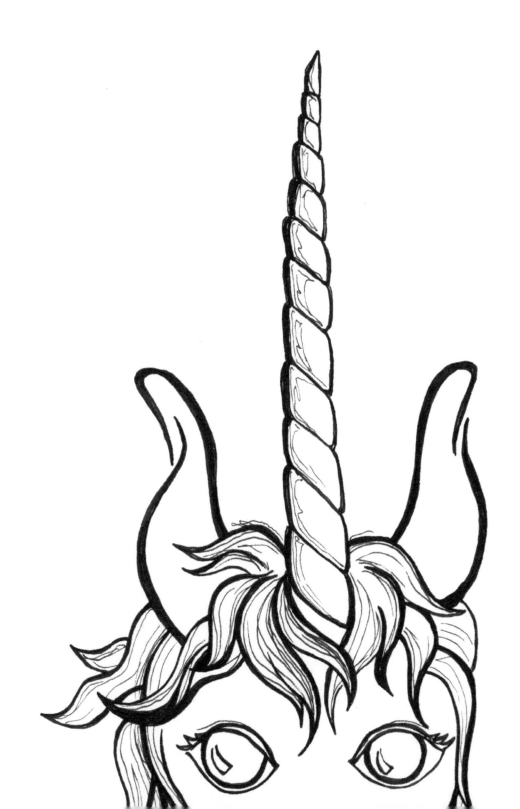

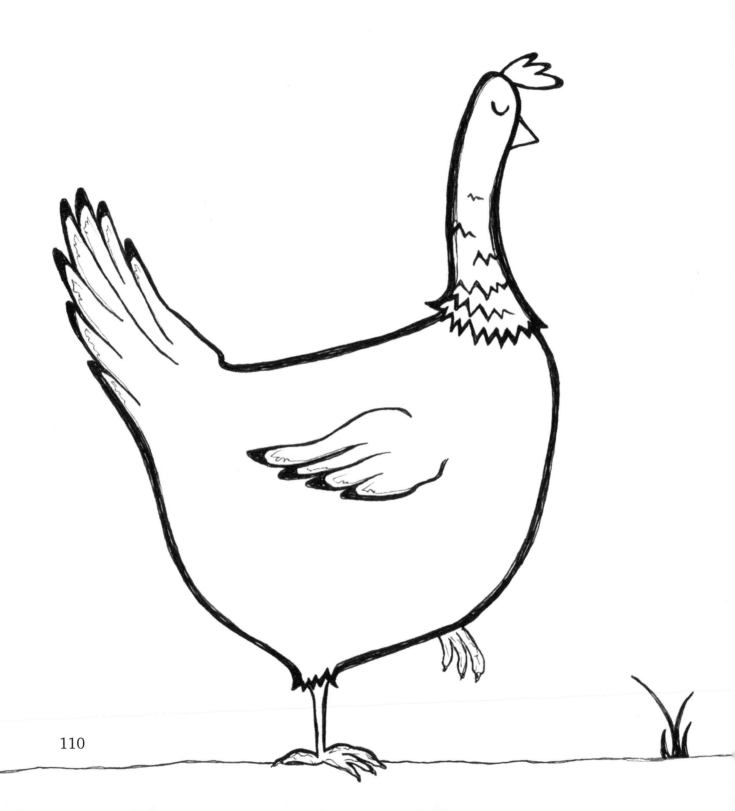

GOOD JOKE

Why did the chicken cross the road
when this side is perfectly fine?

"Maybe he chased a slithering snake,"
said Mr. Fogerty Fline.

"It's that chicken girl. She made him awhirl,"
spoke Mrs. Mewsbury Stine.

"That's insane! He's got no cane!"
yelled old McGrumpety Grine.

"Yoo dee hoo, he's dodging my stew,"
shouted Mrs. Montgomery Myne.

"Maybe to see what else there could be,"
said Lester Hieronymus Pine.

"Could just be looking for what feels more free
Than a chicken on the sideline."

They all sat still, at least until,
laughter burst at the same time.

"That's a good joke. Nearly made me choke,"
said Grine, who sipped his moonshine.

CLEMENTINE CLOOP

"There's hair in my soup!" yelled Clementine Cloop,
Who always likes to complain.
She sets up the story, and tells it with glory,
Then does it all over again.

113

RRRIBBIT

There's a rabbit in the forest.
He sits atop a log,
And always says "rrribbit."
Could it be a furry frog?

HAPPY BIRTHDAY

I want to say much more than
"Happy birthday" to my friend.
So, I'll sing this song I wrote.
If you don't like it, just pretend.

Happy birthday! Yummy cake.
It's your birthday! I love cake.
I have some news about your cake.
My dino ate your birthday cake.

116

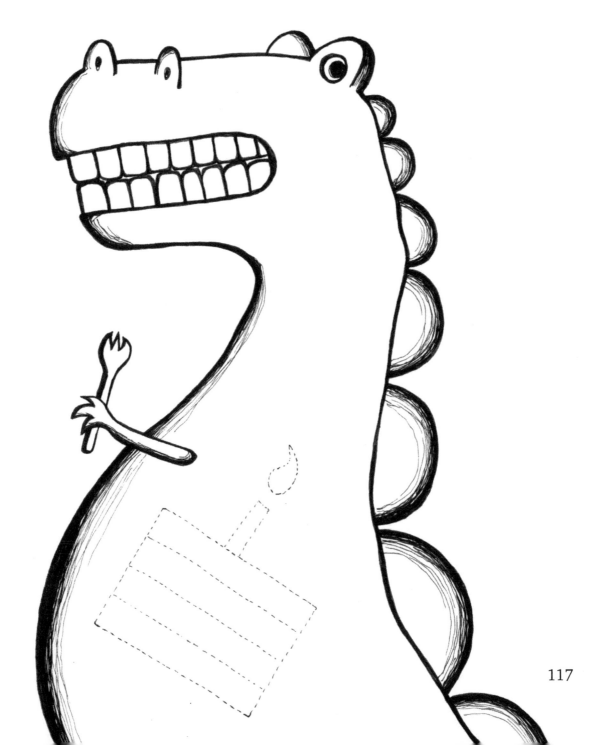

THE RIGHTIES

The Righties are right and will fight you all night.
They want to be right. The most right has the might.
They cling to the thing. They welcome the sting.
To be right with a fight. What a might to be right.

Norm comes along and sings a new song
That shines a new light on this thing about right.
They itch and they stomp, they chatter and clomp,
As Norm shines his light on the very Most Right.

Most Right stood with might, his hands he grips tight,
And Norm held the light just as strong as Most Right.
Most Right felt a thing that he thought he outgrew:
He felt his strength threatened by what he once knew.

His mind flashed to see a small boy chased by bees,
Behind him he heard the whole school laugh and tease.
This day dimmed his light. He became the Most Right.
He now sees a fight isn't always what's right.

He looked straight at Norm, whose smile was bright,
And held out his hand to ask for clear sight.
Norm and Most Right now agree on no fight,
The Righty's new right is the power of light.

119

YAWN

DRAWING

I'm stuck inside my drawing!
Fell into it this morning.
I really wish I didn't
Draw something quite so boring.

GENIUS

You are a genius!
Oh... didn't you know?
A mighty fine genius,
With ideas to grow.

It all just depends.
It's different per day.
What sort of a genius
Will you be today?

ADVENTURE

Let's go on an adventure
And feel so very free.
First things first—let's pack.
Need a minute. Maybe three.

I have to bring this one thing—
It comes in black and red.
I'll need these ten thingy-bobs.
That's what the doctor said.

Of course let's add doohickeys,
They always come in handy.
And each one has a charger—
Waterproof and can get sandy.

Wow! It's four hours later.
Time flies with packing fun.
Do you know of any airline
That checks bags over a ton?

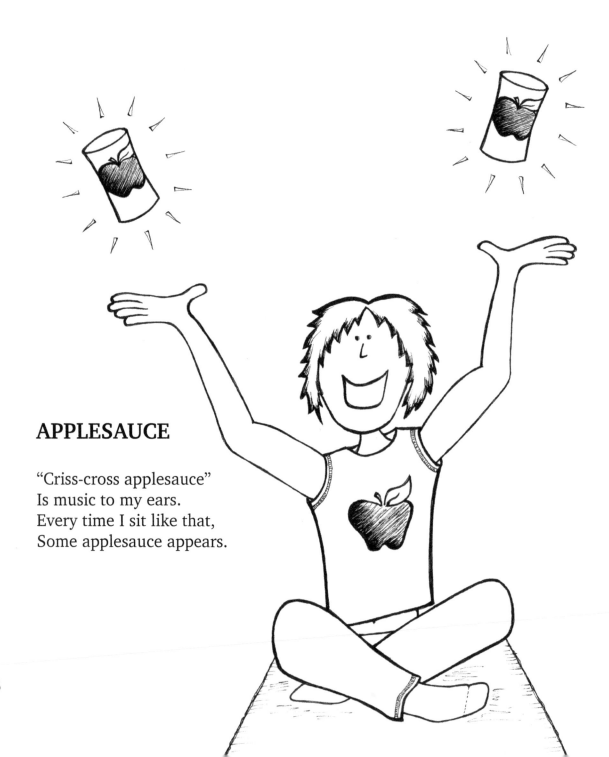

APPLESAUCE

"Criss-cross applesauce"
Is music to my ears.
Every time I sit like that,
Some applesauce appears.

126

THANK YOU

I'm glad to find a place to share
These poems with good folks who care,
So they stop wandering 'round my head.
Thank you, I'll now go back to bed.

INDEX

FOR LUCY, AMIGO MAX & ALL MY HAMSTERS. ♡

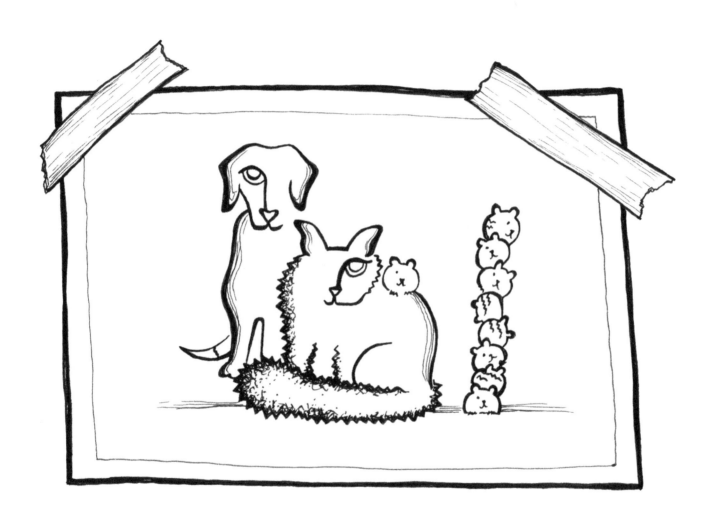

CPSIA information can be obtained
at www.ICGtesting.com
Printed in the USA
BVHW021626010721
610980BV00020B/1795

9 781734 114409